New American Photography

New American Photography

John Lueders-Booth
Jerry Burchfield
Kurt Brabbee
Suzanne Camp Crosby
Avery Danziger
Steven Foster
Brian Francyzk
Jeff Gates
Peter F. Iverson
Celia Jordan
Lou Krueger
Susan Makov
Carol Porter McClintock
Lorie Novak
William Paris
Jack Sal
Karen Savage
Mark Schwartz

Edited and with an introduction
by Steven Klindt

The Chicago Center for
Contemporary Photography
Columbia College
Chicago, Illinois

January 9 - February 21, 1981

Funds for the production of this catalog and exhibit as well as all
the exhibits and programs of the Chicago Center for
Contemporary Photography were provided in part by grants
from the National Endowment for the Arts, a federal agency,
and the Illinois Arts Council, an agency of the state of Illinois.

Acknowledgements

This catalog was produced in conjunction with the exhibit *New American Photography* held at the Chicago Center for Contemporary Photography, Columbia College, Chicago, Illinois in January and February of 1981.

Each photographer in this exhibit is represented by one photograph in this book while there were ten images by each artist in the exhibit.

I am very grateful to the artists for their generous help in putting this venture together. They have all demonstrated amazing patience through all the phone calls, letters, shipping and visits. They are a diverse group of eighteen talented people and it has been a pleasure working with them.

Throughout the country, many people helped me with this exhibit by introducing me to photographers in their regions. I would especially like to thank Tony Decaneas, Chris Enos, David Fahey, Robert Klein, Rod Lazorik and Michael Levine for bringing so many new photographers to my attention.

I wish to thank John Mulvany, Chairman of Columbia College's Photography Department, for his help, his opinions, his insight and for the many valuable hours we spent together looking at photographs for this and other exhibits.

Three people deserve special recognition for the production of this fine catalog. My assistant, Denise J. Miller, prepared the biographies for this catalog with her usual precision and clarity Carl Reisig of Congress Printing maintained his high standards of excellence in printing this book. And Gerry Gall, head of Columbia's printing and design department, has produced a beautiful book. I thank him for his patience and for listening to my suggestions.

This book and exhibit were produced by Columbia College, Chicago, Illinois where the Chicago Center for Contemporary Photography is operated as an exhibit and study program.

Funds for the production of this catalog and exhibit were provided in part by grants from the Illinois Arts Council, an agency of the state of Illinois, and the National Endowment for the Arts, a federal agency. Columbia College appreciates their support and encouragement.

SK

ISBN 0-932026-06-0

Introduction

There seems to be no more natural time than the beginning of a new decade for looking ahead. A new decade makes a good demarcation point for evaluating what has come before and for speculating about what is to come after.

It was this type of examination and reporting that I had in mind in 1979 as I began to bring together photographers for the exhibit *New American Photography*. I set a simple goal for this exhibit: find and exhibit the photographic work that is contemporary in the United States. Pay special attention to work of a less than traditional nature, but make as accurate a survey as possible of the directions in which the practitioners are moving photography.

I soon abandoned two paths I felt at the outset would be ways to structure this exhibit—regionalism and the avant-garde. Photographers are not isolated in their geographic regions anymore. They are as actively mobile as any group of people. Popular publications and an upsurge in the production of photography books have brought the country's photographers to each other. Trends and directions no longer lie within regions, they live and grow within individual photographers.

Contemporary photographers are resistant to the term avant-garde. Not one photographer I spoke with or whose work I saw remotely felt that his or her work captured that pre-eminence of invention or application of new techniques that could be defined as avant-garde. Instead I found photographers who placed themselves solidly in the traditions of artist/photographers. People working hard to perfect their craft and to establish their uniqueness of expression. Artists who want to push photography by testing its limits and all of our preconceived notions of what

photography must be.

These are not new ideas, although the photographs these people make are new and fresh and exciting. The work being produced today, in all likelihood, will become in ten years either mainstream, forgotten or simply the curiosity of a passing fad. In any event it is important to see, document and study these photographs now, and then let time and new photographers do their work.

*　　　*　　　*　　　*

Lou Krueger and **Jack Sal** are working in the mode of *cliché-verre* photography. Krueger's quixotic jewels of fantasy and mythology all employ self portraits. In *Scarecrow and the braintrust* we see the art faculty of Northern Illinois University assemble Krueger (the Scarecrow) as his head awaits placement from atop the central pole. Krueger paints in negative colors on clear Kodalith film, most often combining and sandwiching negatives and then contact printing this painting onto color paper.

Jack Sal's photographs qualify as photographs because they use the medium's most basic elements—light sensitive materials and light. Sal makes ink and pencil drawings on fine paper and then places these drawings in contact with printing out paper and puts them outdoors, using the sun as his light source. Depending on time of day, changes in weather and levels of air pollution, the resulting images are mysterious variations of the original drawn "negatives."

Hand application of color and drawing play a major role in **Susan Makov's** work. She begins with black and white photographs of the Utah landscape and then "imposes" her own

will, colors and forms on them. In this series of *Impositions* as she calls them, we begin to see a thread that runs through the photographers in this exhibit. As artists they are recognizing their ability to alter their subject and to produce a photograph that does not represent in the traditional way.

Another example of camera-less photography is **Jerry Burchfield's** *Pic-A-Shirt* series. By contact printing shirts on Cibachrome material, Burchfield gives us life size images that seem to radiate with an inner glow. Brighter and more intense than real life, these are images with humor and inventiveness.

Kurt Brabbee is a photographer in complete control. His cool and methodical pictures are the products of an artist who knows intimately all the tools at his disposal. He perhaps embodies the best of the new generation of educated artists, combining sculpture, painting, conceptual art and installation art into his final photograph, which is his chosen medium of expression.

Another artist who makes her photographs happen is **Suzanne Camp Crosby**. With a dash of wit, she places items into the landscape that almost seem to fit. The fruit she finds in advertisements never grew that big, that beautiful, that flat. Humor and jokes are rare in photography and are refreshing in Crosby's work.

Perhaps **Mark Schwartz** is a pioneer among photographers in this age of technical advancement and sophisticated equipment. He uses a piece of photography equipment with a well established place in American society—the photo booth. Schwartz's pictures are actually combined strips of images produced by the photo booth at the local variety store that have been washed,

refixed and toned. They are a pastiche of Americana, sequential imagery, the history of photography and wackiness.

Carol Porter McClintock's collages concern themselves more with the accumulation of parts that together better represent a moment, an idea or an occurrence than would one individual photograph. She calls them drawings, and indeed adds handwork to many of the pieces. With their cryptic time and date notations, wind direction indicators and personal notes, they are documents of events we were not privy to. But nonetheless it is their visual impact that engages us.

Combining, altering and controlling images seems to be the recurring element of this exhibit and are all part of **Celia Jordan's** work. She presents her photographs as diptychs and the two pictures (one the reverse of the other) almost create a stereo, 3-D effect of blurred, soft-focussed mundane objects. These curious combinations are both decorative and symbolic—fraught with meaningful and useless maps, cacti, color, scratches and newspapers.

Although **Peter Iverson** also works in diptychs—and sometimes triptychs—the comparison with Jordan's work stops there. Iverson's pictures are color views of the same, or similar, geometric objects. Patterns of light, color and shape are the elements of Iverson's photographs, presented in twos and threes to show us just a taste of the possible combinations.

Fourteen of the eighteen photographers in this exhibit use color materials in some form. This is a testimony to better and easier to use color materials and to widespread inclusion of the teaching of color photography in the curricula of colleges throughout the

country.

The appeal of **Lorie Novak's** photographs is the appearance of strange color in everday interiors. These colors come from sources of projected light—often photographic slides—which change rooms with ghostly and incongruous colors.

Avery Danziger uses the currently popular technique of introducing an electronic flash during a long exposure. As he photographs formal gardens and statuary he is obviously not interested in presenting a true rendition of the setting. He instead wishes to infuse the gardens with life and movement, animating otherwise lifeless objects.

John Lueders-Booth *is* interested in presenting a true likeness, as his role is that of documentarian. If there is one aspect missing from most new photography, it is the social conscience that was prevalent in the 1960s and 1970s. We find it, though, in Booth's work. Booth has spent much time photographing the people and environment of a Massachusetts women's prison. They are revealing photographs, but one must not forget how the presence of a camera and photographer can alter how a person acts in her everyday, albeit exotic, surroundings.

Brian Francyzk's dye transfer prints are also altered documents; here the alteration is subtle through the effects of his printing techniques. His colors are super-saturated, and his original subjects are selected with this eventual effect in mind. A part of new photography is the return to a closer examination and effective use of the long-standing techniques of photography, such as Francyzk's dye transfers.

Not all of **William Paris's** photographs have been set up by the photographer. The importance of his work is his ability to point out the fine line between created fiction and documented fact. There is a back and forth transference of vision in Paris's photographs as the compositions he finds in the world effect the groupings he sets up, and vice versa. The perfect marriage of creative discoverer and the new trend toward arranging things for the photograph.

Karen Savage builds the little room settings in her photographs out of bits and pieces using objects, drawings and magazine photographs. They are throwbacks to doll houses, paper dolls, playing house and fantasized adulthood. They help the photographer and the viewer examine how they and their expectations have changed.

The *BREAST PLATES* series by **Jeff Gates** changed the expectations of the photographer as he progressed with its creation. He has said that the solarization and the other image obfuscating techniques were used "as a veil, separating myself from that fact that I not only was taking photographs of men, but also men in very vulnerable positions." Gates is aware of the difficulty many men have in dealing with other men and as the series progressed he was able to be more direct in photographing other men. Toward the end of the series the images take on a looser and more flowing spirit.

Steven Foster's negative prints reflect the quiet, poetic quality of the music, writing and life style that the artist himself enjoys. The photographs are mysterious and puzzling, to be sure, but are visually rich in their subtle changes of gray and startling reversals of recognized tones. Light becomes dark, and shadow becomes pure white light.

* * * *

As the makers of new American photography throughout the country struggle with their personal ideas and individual approaches, there seems to be a new spirit afoot—to make images of a much more personal nature. The artists in this exhibit demonstrate a greater level of involvement with their subjects and techniques than we have witnessed in the recent past.

Fewer and fewer photographers are content to work only as active observers of the city, people or landscape. They are instead becoming active participants—controlling, directing, changing and, in effect, being in command of their photographs. We have, perhaps, seen no other time when photographers were less interested in what they point their cameras at and more interested in the final object they make, the photograph.

Steven Klindt
Director

The Chicago Center for Contemporary Photography
and the Columbia Galleries
Columbia College, Chicago, Illinois

January 1981

8

The Photographers

Measurements given are in inches, height precedes width and are measurements of the image size of the original piece.

Lou Krueger

Born in Chicago, Illinois, 1948. Currently lives in Syracuse, New York.

Education
Northern Illinois University, B.F.A., 1970 (metals);
Northern Illinois University, M.F.A., 1976 (photography).

Taught
Syracuse University, 1978 to present.

Grants
Ford Foundation Grant, 1978 and 1979.

Selected One Man Exhibits
1977 Southern Illinois University, Carbondale, Illinois
1979 Hammes Gallery, St. Mary's College, Notre Dame, Indiana
1980 Gallery II, Sangren Hall, Western Michigan University, Kalamazoo, Michigan
1980 Pittsburgh Filmmakers Gallery, Pittsburgh, Pennsylvania

Selected Group Exhibits
1977 *Light II*, Humboldt State University, Arcata, California
1978 *The Altered Image*, ARC Gallery, Chicago, Illinois
1978 *Artists of Upstate New York*, Munson-Williams-Proctor Museum, Utica, New York
1979 *Past Masters*, Swen Parson Gallery, De Kalb, Illinois

Collections
Western Michigan University, Kalamazoo, Michigan
Kemper Insurance Collection, Chicago, Illinois
Northern Illinois University, DeKalb, Illinois

Scarecrow and the braintrust, 1977, *cliché-verre*, color negative print, $15^{1}/_{4}$ x $19^{9}/_{16}$

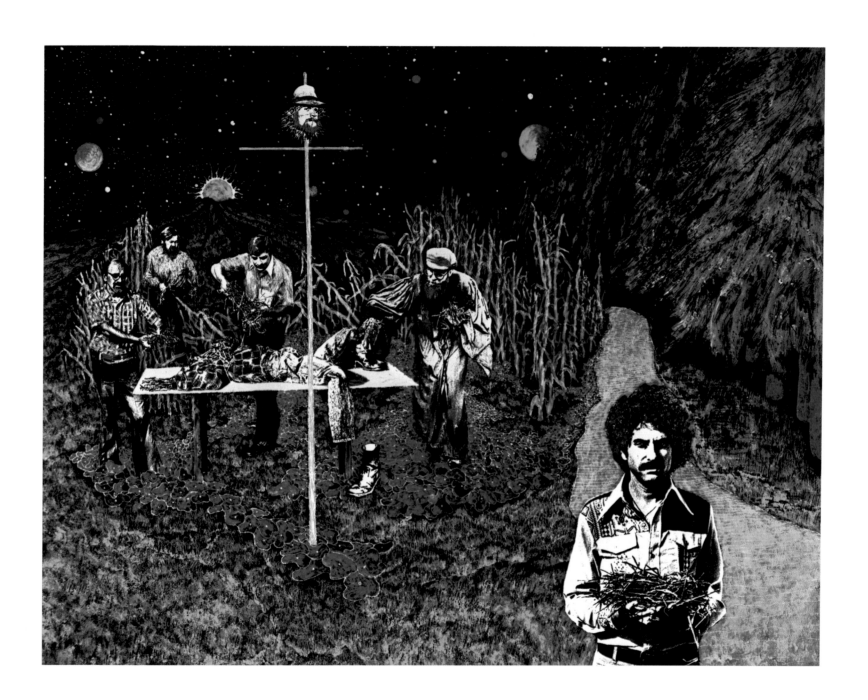

Jack Sal

Born in Waterbury, Connecticut, 1954. Currently lives in New York, New York.

Education
Philadelphia College of Art, B.F.A., 1976 (photography); School of the Art Institute of Chicago, M.F.A., 1978 (photography/painting).

Taught
International Center for Photography, 1980 to present.

Grants
Office of Cultural Affairs of New Haven, Connecticut, 1979. Connecticut Comission on the Arts, 1980.

Selected One Man Exhibits
1978 University of South Dakota, Vermillion, South Dakota
1978 Archetype Gallery, New Haven, Connecticut
1980 Photo Graphics Workshop, New Canaan, Connecticut
1980 Northlight Gallery, Arizona State University, Tempe, Arizona

Selected Group Exhibits
1979 *The Photographer's Hand*, International Museum of Photography/George Eastman House, Rochester, New York
1980 *Prints in the Cliché-Verre, 1839 to the Present*, Detroit Institute of Arts, Detroit, Michigan

Publications
Jack Sal Drawings/Notations, International Museum of Photography/George Eastman House
Prints in the Cliché-Verre, Detroit Institute of Arts, Detroit, Michigan

Collections
Yale University Art Gallery, New Haven, Connecticut
International Museum of Photography/George Eastman House, Rochester, New York
The Detroit Institute of Arts, Detroit, Michigan
The Center for Creative Photography, Tucson, Arizona
Northlight Gallery, Arizona State University, Tempe, Arizona

untitled, 1979, *cliché-verre*, printing out paper, 20 x 24

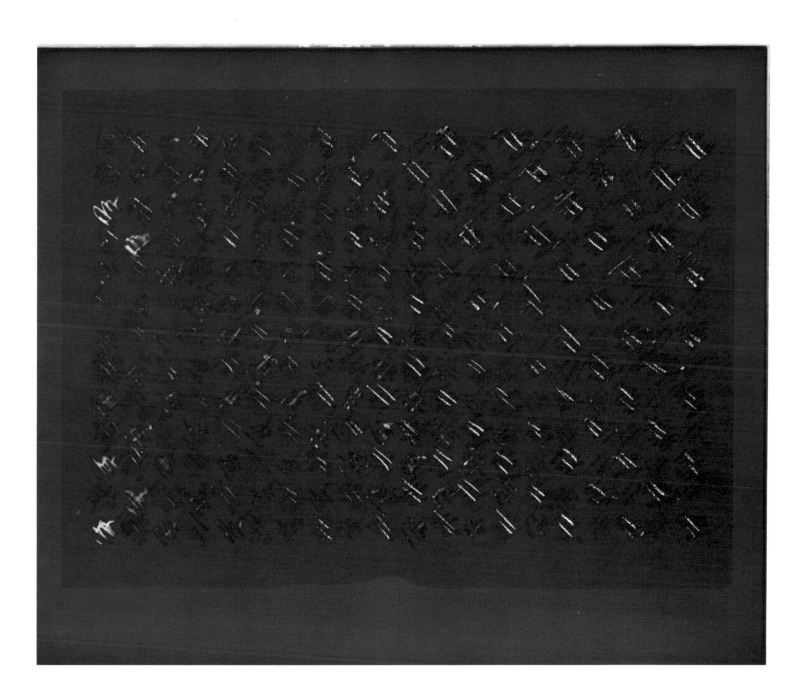

Susan Makov

Born in Roslyn Heights, New York, 1952. Currently lives in Ogden, Utah.

Education
Syracuse University, B.F.A., 1974; Brighton Polytechnic, England, 1975; State University of New York, Buffalo, M.F.A., 1977.

Taught
Weber State College, 1977 to present.

Selected Group Exhibits
1976 *Fifth British International Print Biennale*, Bradford City Museums, Bradford, England
1978 *Four Corners Photography Exhibition*, Arizona State University, Tempe, Arizona
1979 *New Photographics '79*, Central Washington University, Ellensburg, Washington
1979 *Utah '79*, Salt Lake City Art Center, Salt Lake City, Utah
1980 *Multiples '80*, Contemporary Arts Center, New Orleans, Louisiana

Collections
Bradford City Art Gallery and Museums, Bradford, England
University of Buffalo, New York
Arizona State University, Tempe, Arizona

Impositions #28, 1978, hand colored gelatin silver print, 9 x 13³/₈

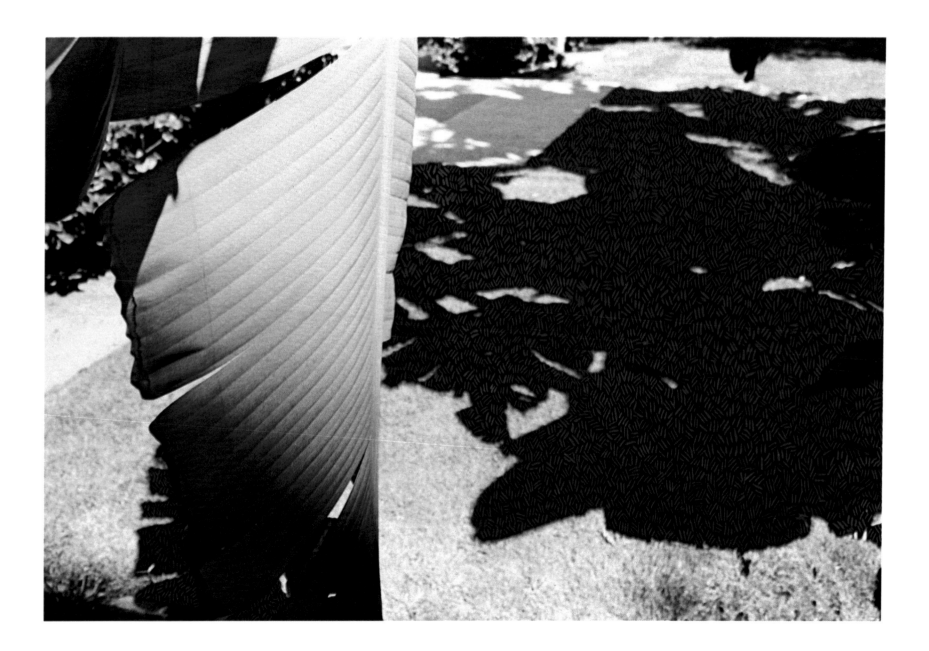

Jerry Burchfield

Born in Chicago, Illinois, 1947. Currently lives in Laguna Beach, California.

Education
California State University, Fullerton, B.A., 1971 (photo-communications); California State University, Fullerton, M.A., 1977 (photography).

Taught
University of California, Los Angeles, 1979 to present; California State University, Fullerton, 1978 to present (part-time); Saddleback College, 1977 to present (part-time); Laguna Beach School of Art, 1975 to present.

Selected One Man Exhibits
1974 *Color Photograms*, Laguna Beach Museum of Art, Laguna Beach, California
1976 *Color Photographs*, Arco Center for Visual Art, Los Angeles, California
1977 Tyler School of Art, Philadelphia, Pennsylvania
1979 Foto Gallery, New York, New York
1979 Silver Century Gallery, Novato, California
1980 Susan Spiritus Gallery, Newport Beach, California
1980 *Night Walking*, Fine Arts Gallery, Colorado Mountain College, Breckenridge, Colorado

Selected Group Exhibits
1975 *California Invitational*, Cypress College, Cypress, California
1976 *New Photographics '76*, Central Washington State College, Ellensburg, Washington
1977 *Variations With No Theme*, Los Angeles County Museum of Art, Los Angeles, California
1978 *Contemporary California Photography*, Camerawork Gallery, San Francisco, California
1979 *Attitudes, Photography in the 1970s*, Santa Barbara Museum of Art, Santa Barbara, California
1980 Minneapolis Institute of Art, Minneapolis, Minnesota

Publications
"The West: Points of View," *New West Magazine*, November 1979
Camera, Switzerland, 1980

Collections
Security Pacific Bank, Los Angeles, California
Los Angeles Center for Photographic Studies, Los Angeles, California
St. Louis Museum of Art, St. Louis, Missouri
Minneapolis Institute of Arts, Minneapolis, Minnesota

Jerry Burchfield's photographs are courtesy of the G. Ray Hawkins Gallery, Los Angeles, California.

Pic-A-Shirt (909), 1980, Cibachrome contact print, 20 x 16.

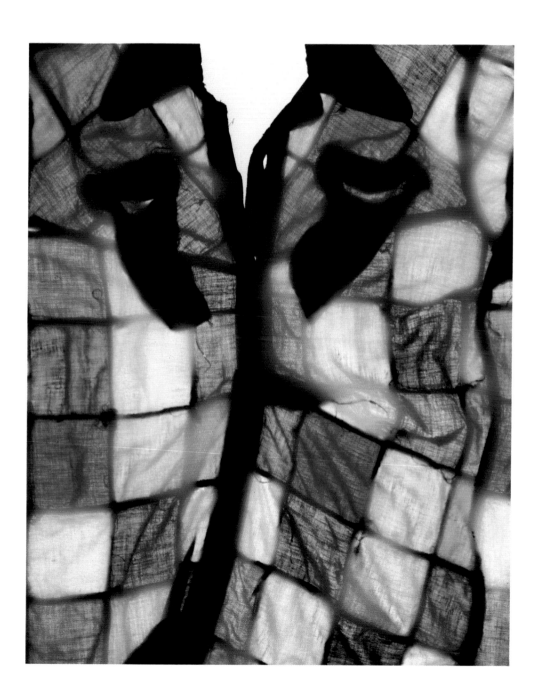

Kurt Brabbee

Born in Neenah, Wisconsin, 1950. Currently lives in Chicago,
Illinois.

Education
San Francisco Art Institute; Rochester Institute of Technology,
B.F.A., 1975; Florida State University.

Sidewall, 1980, color negative print, $13^7/_8$ x $17^7/_8$

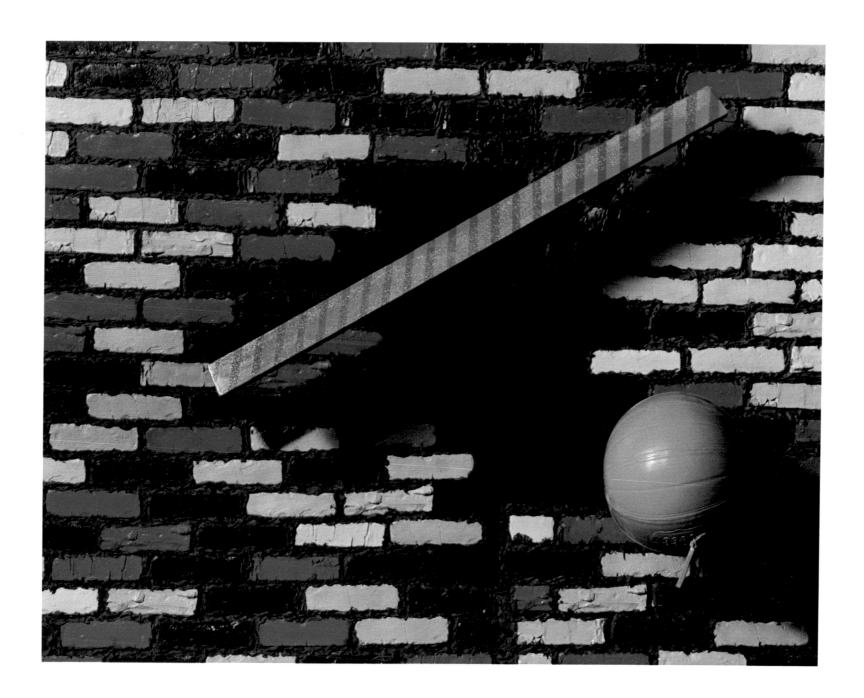

Suzanne Camp Crosby

Born in Roanoke, Virginia, 1948. Currently lives in Tampa, Florida.

Education
University of Florida, Gainesville, B.F.A., 1970 (painting); University of South Florida, M.F.A., 1976 (photography).

Taught
Hillsborough Community College, Ybor Campus, 1979 to present (part-time).

Grants
National Endowment for the Arts and Southeastern Center for Contemporary Art, 1978-1979.
Florida Fine Arts Council Individual Artist Fellowship, 1979-1980.

Selected One Woman Exhibits
1978 Fine Arts Gallery, University of West Florida, Pensacola, Florida
1980 The Gallery, Brevard Community College, Cocoa, Florida
1980 *Images...Female*, The Florida Gulf Coast Art Center, Bellaire, Florida

Selected Group Exhibits
1975 *1975 New Orleans Biennial Exhibition*, New Orleans Museum of Art, New Orleans, Louisiana
1976 *Professional Women Artists of Florida*, Lowe Museum, Miami, Florida
1977 *Florida Women Artists*, Meatpackers Gang Gallery, Pensacola, Florida
1978 *Six Women Photographers*, Atlanta Gallery of Photography, Atlanta, Georgia
1979 *Hot Shots: 25 Photographers*, Southeastern Center for Contemporary Art, Winston-Salem, North Carolina
1980 *Southeastern Seven III*, Southeastern Center for Contemporary Art, Winston-Salem, North Carolina

Publications
"Portfolio," *Petersen's Photographic Magazine,* January 1976
Joyce Tenneson Cohen, *In/Sights: Self-portraits* By Women, 1978

Collections
The Chicago Center for Contemporary Photography, Columbia College, Chicago, Illinois

Pine-Apple Tree, 1980, Cibachrome print, $9^{15}/_{16}$ x $9^{15}/_{16}$

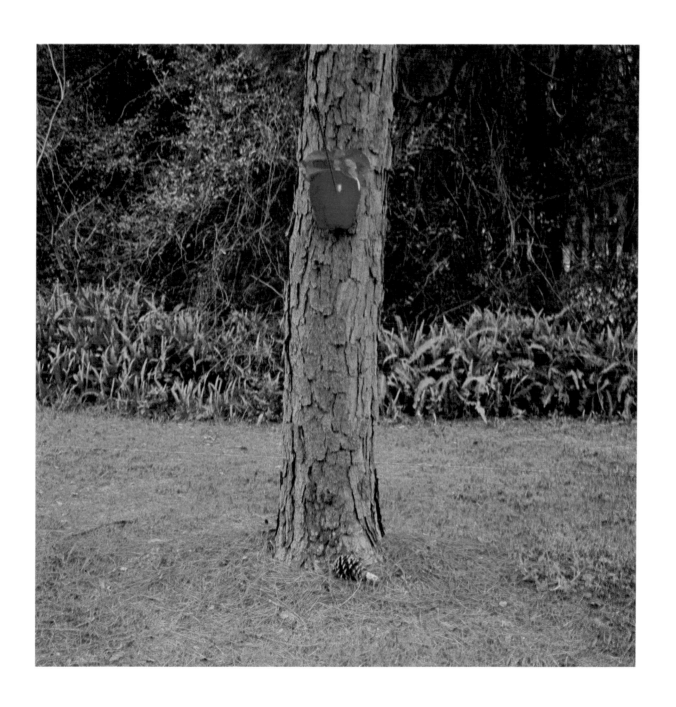

Mark Schwartz

Born in Fall River, Massachusetts, 1950. Currently lives in Lakewood, Ohio.

Education
Rutgers University, B.A., 1977; Princeton University, 1975-1977; Ohio University, M.F.A., 1979 (photography and art history).

Taught
Rutgers University, 1975-1979; Ohio University, 1978-1979; Cleveland State University, 1980 to present.

Grants
Ohio University Research Institute Grant, 1979.
Ohio Arts Council Fellowship Award, 1979.
Ohio Arts Council Project Support, 1980.

Selected One Man Exhibits
1978 Rutgers University, New Brunswick, New Jersey
1979 Princeton University, Princeton, New Jersey
1980 Siegfred Gallery, Ohio University, Athens, Ohio
1980 Light Gallery, New York, New York

Selected Group Exhibits
1977 *International Invitational of Photography*, Union
 Carbide Building, New York, New York
1978 *International Invitational of Photography*, French
 Embassy, New York, New York
1979 *American Vision*, Grey Galleries, New York University,
 New York, New York

1979 *Five Photographers*, Tangemen Gallery, University of
 Cincinnati, Cincinnati, Ohio
1979 *f-o*, Kansas City Art Institute, Kansas City, Missouri
1979 *The Contemporary Platinotype*, Rochester Institute of
 Technology, Rochester, New York
1980 *U.S. Eye*, Visual Studies Workshop, Rochester, New
 York
1980 *Segments of Series*, Center for Contemporary Art, Los
 Angeles, California

Collections
Kansas City Art Institute, Kansas City, Missouri
Rutgers University, New Brunswick, New Jersey
Ohio University, Athens, Ohio
Rochester Institute of Technology, Rochester, New York
Rhode Island School of Design, Providence, Rhode Island
Bellevue Art Museum, Bellevue, Washington
Murray State University, Murray, Kentucky

Muybridge in Motion #2, 1979, gold toned photo booth prints (collaged), $9^1/_2$ x $15^1/_4$

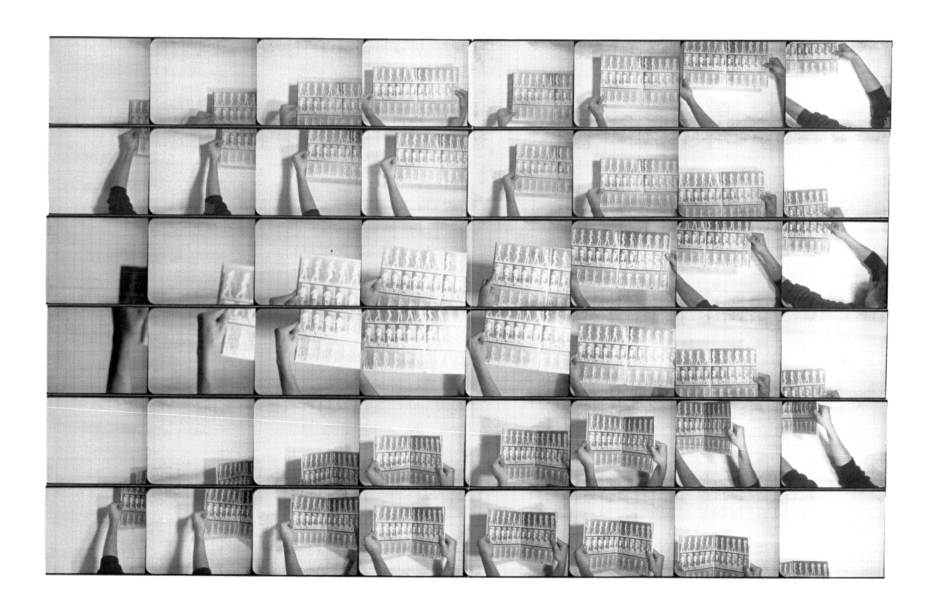

Carol Porter McClintock

Born in Modesto, California, 1946. Currently lives in Freeville, New York.

Education
University of California, Santa Barbara, B.S., 1968 (psychology); State University of New York, Buffalo, M.S., 1973 (animal behavior/zoo management and design); Syracuse University, M.F.A., 1980 (site specific artmaking/video).

Taught
Cornell University, 1975-1978; Syracuse University, 1978-1979.

Selected One Woman Exhibits
1976 Ithaca House Gallery, Ithaca, New York
1980 Ithaca House Gallery, Ithaca, New York

Selected Group Exhibits
1979 The Center for Contemporary Art, Los Angeles, California
1980 Silver Image Gallery, Ohio State University, Columbus, Ohio
1980 *Alternatives 1980*, Ohio University, Athens, Ohio
1980 Centre de Documentacio d'art Actual, Barcelona, Spain

10 August 1980, collage, color negative print mounted on paper, $12^3/_4$ x $22^1/_4$ (paper size)

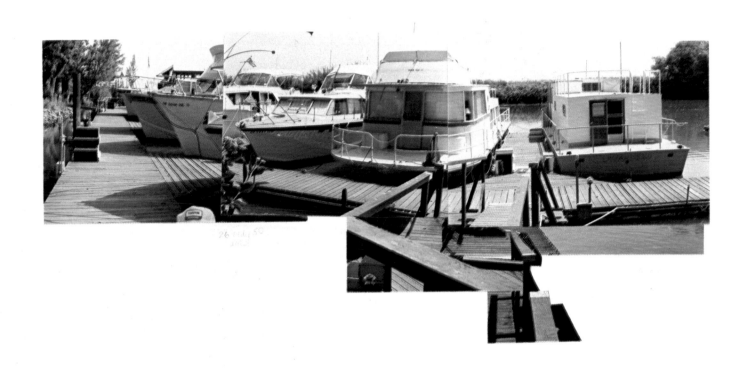

26 aug. 50

c. porter mcclintock 17 august 198_

Celia Jordan

Born in Brownsville, Texas, 1951. Currently lives in
Maplewood, Missouri.

Education
University of New Mexico, B.F.A., 1977; Tyler School of Art,
Temple University, M.F.A., 1980.

Taught
Cheltenham School of Fine Arts, 1979-1980; St. Louis
Community College, 1980 to present.

Selected Group Exhibits
1977 *Contemporary Landscape*, The ASA Gallery,
 Albuquerque, New Mexico
1979 *Women Artists in Albuquerque*, The Albuquerque Little
 Theatre, Albuquerque, New Mexico
1980 *Alternatives 1980*, University of Ohio, Athens, Ohio
1980 *New Photographics*, Spurgeon Gallery, Central
 Washington University, Ellensburg, Washington
1980 *Introductions 1980*, A.J. Wood Gallery, Philadelphia,
 Pennsylvania
1980 *Women and Nature*, Tyler School of Art, Philadelphia,
 Pennsylvania

Border Series, Blue Leaves, 1980, color negative prints,
$9^7/_8$ x $13^3/_4$

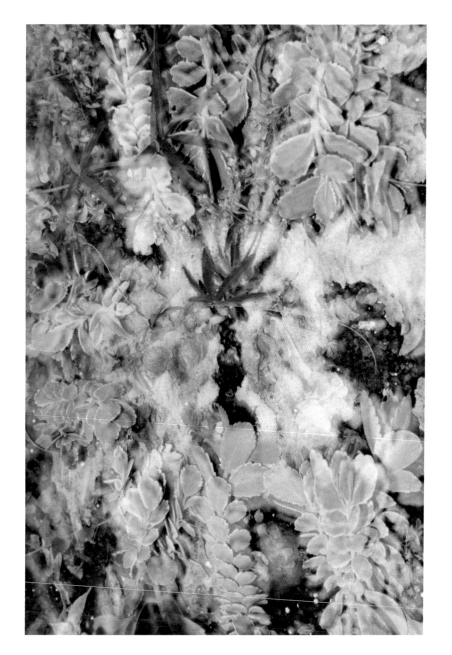
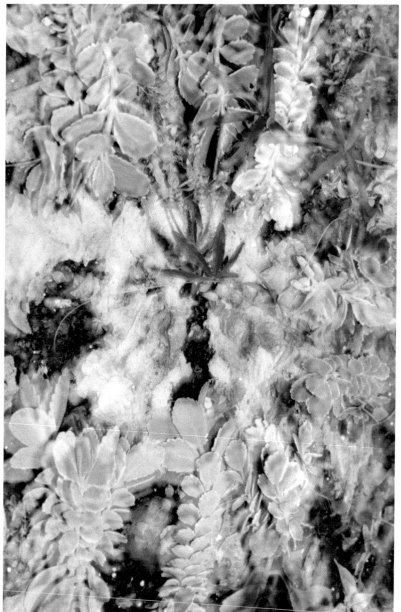

Peter F. Iverson

Born in Palo Alto, California, 1949. Currently lives in
Tallahassee, Florida.

Education
Humboldt State University, B.A., 1977 (studio art); Purdue
University, M.A., 1978 (studio art); Florida State University,
M.F.A., 1980 (studio art).

Taught
Tallahassee Community College, 1980 to present.

Grants
Florida Fine Arts Council, Emerging Artist Fellowship, 1980.

Selected Group Exhibits
1978 *Markings*, Purdue University, West Lafayette, Indiana
1980 *Alternatives 1980*, Spaces Gallery, Ohio University,
 Athens, Ohio
1980 *Arts Works—13*, Florida State University, Tallahassee,
 Florida

Collections
State of Florida, House of Representatives

Diptych #16, 1979, color negative print, on 11 x 14 paper,
image sizes $3^9/_{16}$ x $5^1/_2$

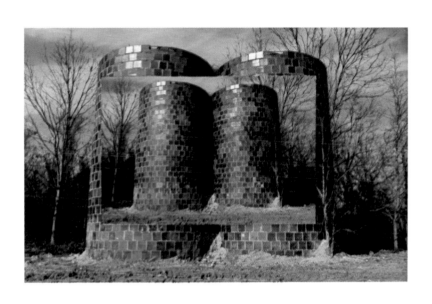 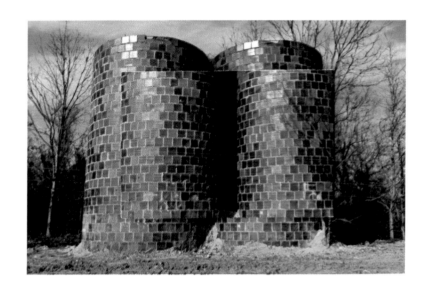

Lorie Novak

Born in Los Angeles, California, 1954. Currently lives in Medford, Massachusetts.

Education
University of California, Los Angeles, 1971-1973; Stanford University, B.A., 1975 (art and psychology); School of the Art Institute of Chicago, M.F.A., 1979.

Taught
University of Massachusetts, Harbor Campus, 1979 to present; Tufts University, 1980 to present.

Grants
Humanities Award for Studio Art, Stanford University, 1975.
Polaroid Corporation Grant, 1978-1980.

Selected One Woman Exhibits
1979 Photoworks, Chicago, Illinois
1980 Camerawork, San Francisco, California

Selected Group Exhibits
1979 *Color: An Invitation Photography Exhibit,* Moming Dance and Arts Center, Chicago, Illinois
1980 *Pure Color*, Kiva Gallery, Boston, Massachusetts
1980 *Into the Eighties: New England Photography*, Thorne Sagendorph Art Gallery, Keene, New Hampshire
1980 *Contemporary Photographs*, Fogg Art Museum, Cambridge, Massachusetts

Publications
"New Images," *Popular Photography*, Semptember 1979
"Photography Annual 1980-1981," *Popular Photography*

Collections
Fogg Art Museum, Cambridge, Massachusetts
Museum of Modern Art, New York, New York
Polaroid Collection, Cambridge, Massachusetts
Stanford University Art Museum, Stanford, California

Lorie Novak's photographs are courtesy Kiva Gallery, Boston, Massachusetts.

untitled, 1980, color negative print, 14 x 14

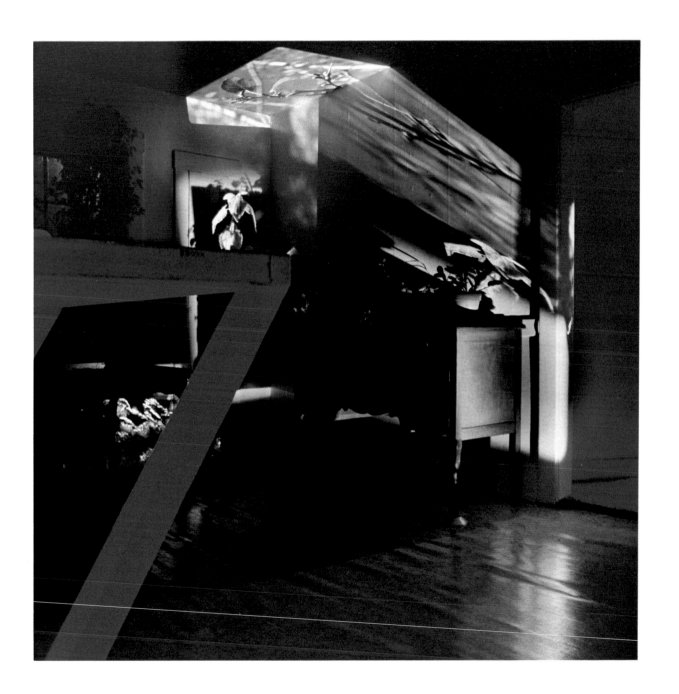

Avery Danziger

Born in Chapel Hill, North Carolina, 1953. Currently lives in
Los Angeles, California.

Education
University of North Carolina, Chapel Hill; Eisenhower College;
Instituto Allende, San Miguel de Allende, Mexico.

Grants
National Endowment for the Arts, Photography Fellowship,
1979.

Selected One Man Exhibits
1977 Instituto Allende, San Miguel de Allende, Mexico
1980 Foto Gallery, New York, New York
1980 BC Space Gallery, Laguna Beach, California

Selected Group Exhibits
1979 *A Selection of Color Photographs*, Cirrus Gallery, Los
 Angeles, California
1980 *Magic Silver Show*, Murray State University, Murray,
 Kentucky

Collections
Museum of Modern Art, New York, New York
San Francisco Museum of Modern Art, San Francisco,
 California
Bibliotecque National, Paris, France
Chicago Center for Contemporary Photography, Columbia
 College, Chicago, Illinois

in the garden of babylon #12, 1979, color negative print,
$12^{1}/_{2}$ x $18^{3}/_{4}$

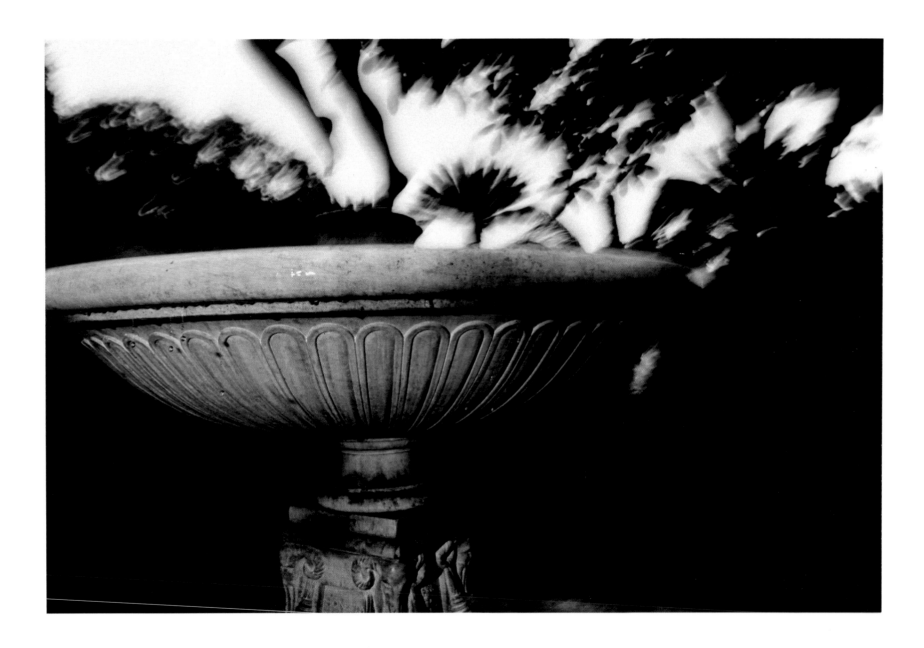

John Lueders-Booth

Born in Boston, Massachusetts, 1935. Currently lives in
Cambridge, Massachusetts.

Education
Harvard University, Ed.M., 1978.

Taught
Carpenter Center for the Visual Arts, Harvard University, 1971
to present; Massachusetts Prison Art Project at Massachusetts
Correctional Institution in Framingham, 1977.

Grants
National Endowment for the Arts, Photography Fellowship,
1981.

Selected One Man Exhibits
1977 Envision Gallery, Boston, Massachusetts
1978 The Art Institute of Boston, Boston, Massachusetts
1978 Robert Freidus Gallery, New York, New York
1978 Ohio State University, Columbus, Ohio

Selected Group Exhibits
1972 *Photovision*, Boston Center for the Arts, Boston,
 Massachusetts
1978 *The Inclusive Image*, Wellesley College, Wellesley,
 Massachusetts
1980 *Into the Eighties: New England Photography*, Thorne
 Sagendorph Art Gallery, Keene, New Hampshire
1980 *Mystic Photo II*, Mystic Art Center, Mystic, Connecticut

Tracy, Framingham Prison for Women, 1979, color negative
print, $10^5/_8$ x $15^1/_2$

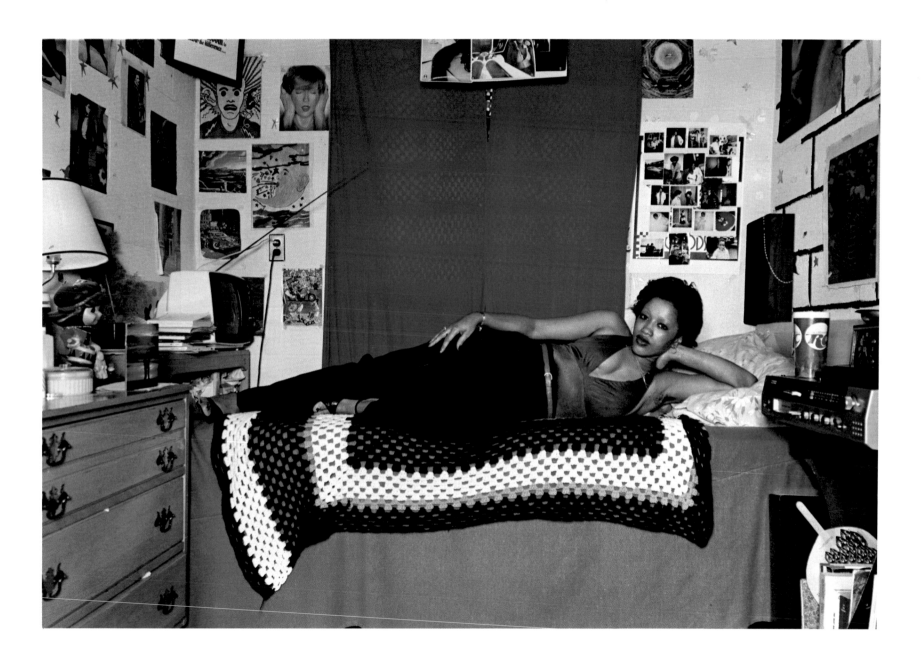

Brian Franczyk

Born in Waukegan, Illinois, 1955. Currently lives in Chicago, Illinois.

Education
Institute of Design, Illinois Institute of Technology, B.S., 1979 (photography).

Grants
Illinois Arts Council Project Completion Grant, 1980.

Selected One Man Exhibits
1976 Institute of Design, Chicago, Illinois
1978 Institute of Design, Chicago, Illinois

Selected Group Exhibits
1977 Darkroom Gallery, Denver, Colorado
1977 School of the Art Institute of Chicago, Illinois
1978 Darkroom Aids Gallery, Chicago, Illinois
1979 Kansas City Art Institute, Kansas City, Missouri
1980 *Illinois Photographers '80*, Illinois State Museum, Springfield, Illinois

untitled, 1980, dye transfer print, $5^3/_8$ x $8^5/_{16}$

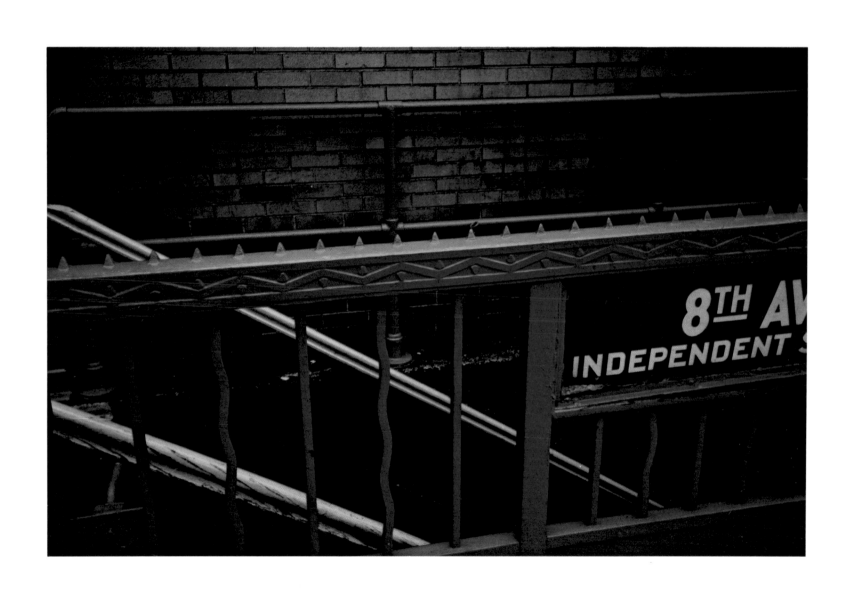

William Paris

Born in Rochester, New York, 1954. Currently lives in
Rochester, New York.

Education
University of Rochester College of Arts and Sciences, B.A.,
1976 (psychology); Visual Studies Workshop, M.F.A., 1979
(photography).

Taught
University of Rochester, 1977-1978.

Selected One Man Exhibits
1976 University of Rochester, Little Gallery, Rochester, New
 York
1977 Visual Studies Workshop, M.F.A. Gallery, Rochester,
 New York

Selected Group Exhibits
1980 *U.S. Eye*, Visual Studies Workshop, Rochester, New
 York
1980 *Exhibition '80,* Albany, New York

untitled, 1980, gelatin silver print, $10^{1}/_{16}$ x $13^{1}/_{16}$

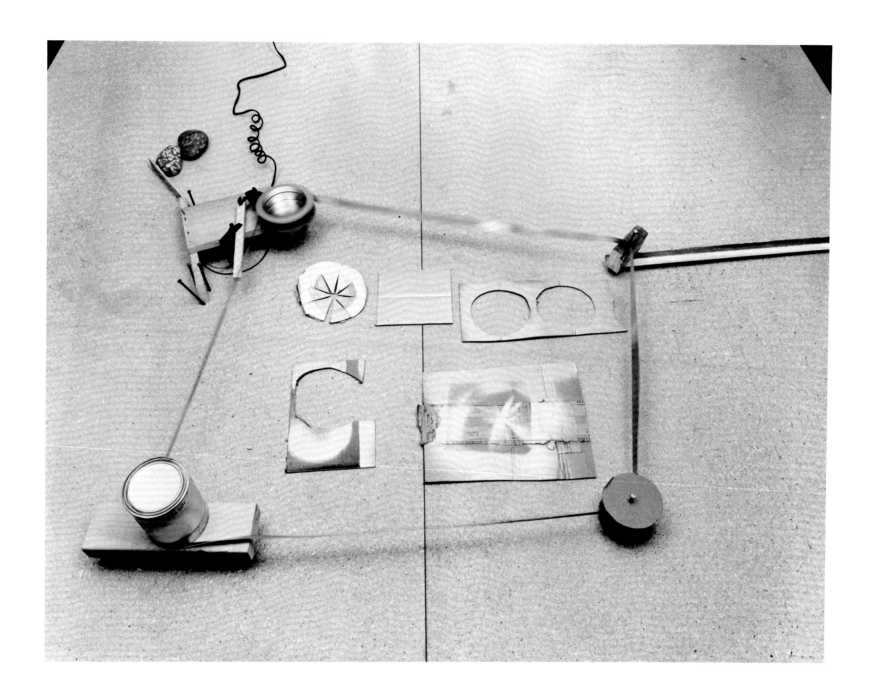

Karen Savage

Born in Berwyn, Illinois, 1948. Currently lives in Oak Park, Illinois.

Education
School of the Art Institute of Chicago, B.F.A., 1970;
School of the Art Institute of Chicago, M.F.A., 1972.

Taught
School of the Art Institute of Chicago, 1973 to present.

Selected One Woman Exhibits
1978 Midway Studios, University of Chicago, Chicago, Illinois
1979 *Places in Time,* Iris Photographic Print Works, Asheville, North Carolina

Selected Group Exhibits
1975 *Photo Flow—New Dimensions,* Women's Interart Center, New York, New York
1976 *Footprint*, Davidson Galleries, Seattle, Washington
1976 *Colorprint U.S.A.,* Texas Tech University, Lubbock, Texas
1978 *Signs and Measures, Marks of Man,* Evanston Art Center, Evanston, Illinois
1978 *Illinois Photographers '78,* Illinois State Museum, Springfield, Illinois
1980 *Detroit National Print Symposium Exhibition,* Cranbrook Museum, Bloomfield Hills, Michigan
1980 *Midwest Photography Invitational*, University of Wisconsin, Green Bay, Wisconsin

Collections
The Art Institute of Chicago, Chicago, Illinois
Mundelein College, Chicago, Illinois

Interior, 1980, gelatin silver print $8^3/_8$ x $12^{11}/_{16}$

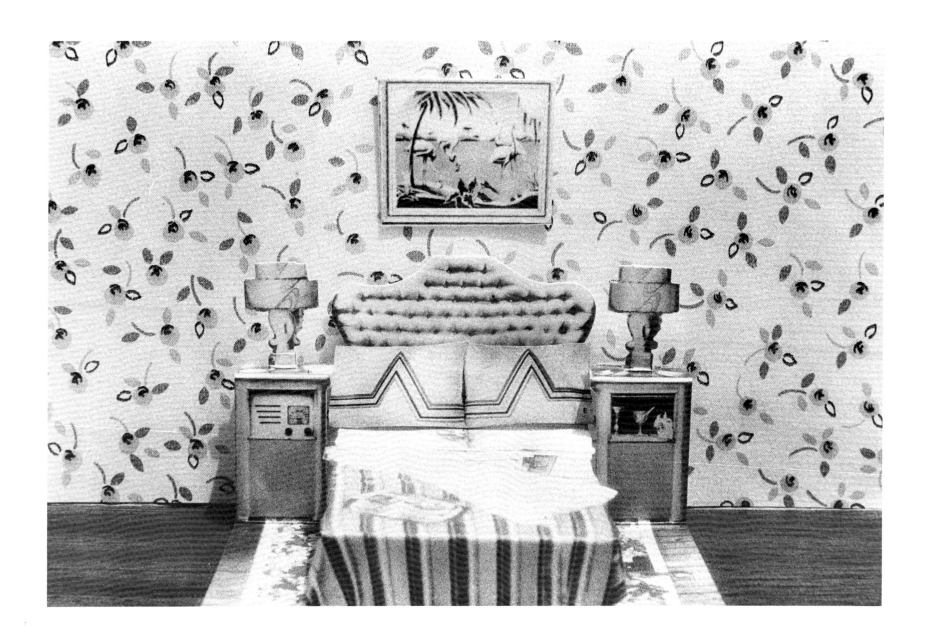

Jeff Gates

Born in Los Angeles, California, 1949. Currently lives in Los Angeles, California.

Education
Michigan State University, B.A., 1971 (political science); University of California, Los Angeles, M.A., 1973 (photography and design); University of California, Los Angeles, M.F.A., 1975 (photography and design).

Taught
Chaffey College, 1976 to present; Pasadena City College, 1976 to present; Cerritos College, 1977 to present; University of California, Los Angeles, 1977 to present.

Selected One Man Exhibits
1977 Spectrum Art Photographic Gallery, Barcelona, Spain
1978 La Photo Galeria, Madrid, Spain
1979 Tyler School of Art, Temple University, Philadelphia, Pennsylvania
1980 San Francisco Camerawork Gallery, San Francisco, California
1980 University of Colorado, Boulder, Colorado

Selected Group Exhibits
1976 *Contemporary American Photography: The UCLA Collection*, Frederick S. Wight Gallery, University of California, Los Angeles, California
1978 *Self-Portraiture*, Northlight Gallery, Arizona State University, Tempe, Arizona

1979 *Southern California Photography Invitational*, Fischer Gallery, University of Southern California, Los Angeles, California
1979 *Photographic Directions: Los Angeles, 1979*, Security Pacific Building, Los Angeles, California
1980 *The Figure in Motion*, Viviane Esders Gallery, Paris, France

Publications
Creative Camera, Great Britain, October 1979
"Photography Annual 1980-1981," *Popular Photography*

Collections
Polaroid Collection, Amsterdam, Holland
Victoria and Albert Museum, London, England
Los Angeles County Museum of Art, Los Angeles, California
Oakland Museum, Oakland, California
Center for Creative Photography, University of Arizona, Tuscon, Arizona
Minneapolis Institute of the Arts, Minneapolis, Minnesota

BREAST PLATES: Fig. 21, 1979, gelatin silver print, 19 x 19

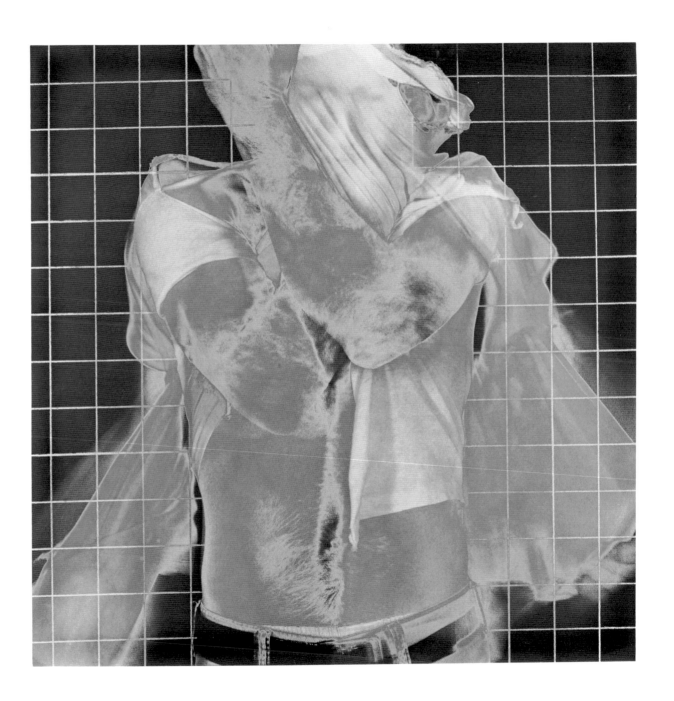

Steven Foster

Born in Piqua, Ohio, 1945. Currently lives in Milwaukee, Wisconsin.

Education
Rochester Institute of Technology, A.A.S., 1965; Institute of Design, Illinois Institute of Technology, B.S., 1968; University of New Mexico, M.F.A., 1972.

Taught
Georgia State University, 1972-1975; University of Wisconsin, Milwaukee, 1976 to present.

Grants
Wisconsin Arts Board Visual Arts Fellowship, 1977.
Wisconsin Arts Board Project Grant-in-Aid, 1978 and 1980.

Selected One Man Exhibits
1975 Nexus Gallery, Atlanta, Georgia
1978 Renaissance Society Galleries, The University of Chicago, Illinois
1978 Nexus Gallery, Atlanta, Georgia
1980 Frumkin Gallery, Chicago, Illinois

Selected Group Exhibits
1967 Underground Gallery, New York, New York
1969 *Vision and Expression*, International Museum of Photography/George Eastman House, Rochester, New York
1978 *Wisconsin Directions II*, Milwaukee Arts Center, Milwaukee, Wisconsin
1979 Los Angeles Center for Photographic Studies, Los Angeles, California
1979 *American Photography of the 1970s*, Art Institute of Chicago, Illinois

Publications
Peter Bunnell, Alan Trachtenberg, eds., *The City*, Oxford University Press, 1971
Jerry Korn, ed., *The Print*, Time/Life Photography Series, 1970

from the Makom series, 1978-1979, gelatin silver print, $13^5/_8$ x $13^5/_8$

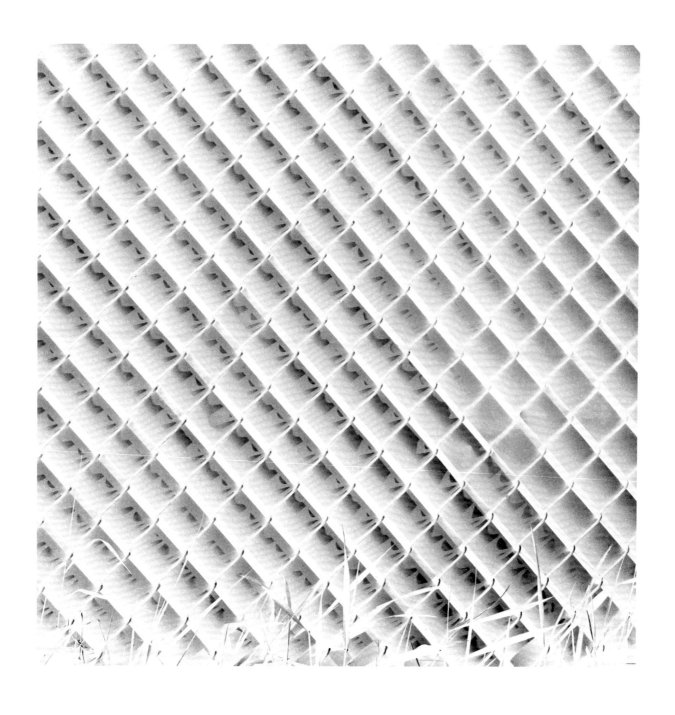

Colophon

New America Photography was set in Stymie type face. Three thousand copies were printed and bound by Congress Printing Company, Chicago, Illinois. The cover stock is 100 lb. Cameo Dull and the paper stock is 100 lb. Cameo Dull.

Design and production: Gerry Gall
Typesetting: Cheri Dahlstrom
Separations: Maurice Davila, Graphic Associates